BLACKBOARD DRAWING

BLACKBOARD DRAWING

by

Mildred Swannell

YESTERDAY'S CLASSICS

ITHACA, NEW YORK

This edition, first published in 2021 by Yesterday's Classics, an imprint of Yesterday's Classics, LLC, is an unabridged republication of the text originally published by Macmillan and Co., Ltd. in 2021. For the complete listing of the books that are published by Yesterday's Classics, please visit www.yesterdaysclassics.com. Yesterday's Classics is the publishing arm of the Gateway to the Classics which presents the complete text of hundreds of classic books for children at www.gatewaytotheclassics.com.

ISBN: 978-1-63334-145-6

Yesterday's Classics, LLC
PO Box 339
Ithaca, NY 14851

CONTENTS

PREFACE

THE value of Drawing as a means of education cannot be over-estimated. For some years past attention has been directed to this branch of the school curriculum, but more especially since Pestalozzi and Friedrich Fröbel pointed out the significant part it plays in the development of the little child. The first expressions of the baby are shown in the movements of the arms and legs, in screams, and later on in various guttural sounds, but after a certain period of the development of purely animal strength, the child desires to touch and handle everything he sees: second only to the need of movement is that of touch.

For a time the mere feeling and grasping surrounding objects contents him, but he will soon need something more: "it is a necessity of the child's mind to give out again in concrete form the ideas and images which it has taken into itself, and thus to fix in clear objective shape the dim undefined images floating in its little brain." As a step towards this, the child's favourite occupation is to dabble its hands in some soft substance such as earth, clay, putty, and sand. Gradually he attempts to mould something he has seen in these pliable substances, and modelling becomes one of the first necessities of the child's life. When clay and sand are not to be obtained he uses sticks, beads, bricks, shells: anything and everything will be made to play their part in the construction of wonderful edifices. Later on drawing will be attempted as another means of making clear the child's own impressions of the external world. The outlines of things are first perceived by the child. Notice how the baby will feel all round the lines marking the limits of different things: the edge of the table, his chair, and toy. The principal lines are noticed and drawn first: there are no curves, no surfaces, no fillings in of any description.

The most uncivilised races make use of straight lines only when ornamenting their gourds, shields, and household utensils; the curve seems to mark a considerable degree of artistic culture, and as the baby develops in exactly the same order as does the race, we find the earliest representations of the little child to be straight lines—a bird flying overhead, a tree, a dog, a man, are all represented at first by a straight line in different positions.

A large tray filled with sand is an invaluable addition to nursery requisites. On this the child may receive his first

drawing lessons. Either by means of a pointed stick, or with the child's own finger, all kinds of objects may be drawn. Later on a small blackboard of about 28 x 20 inches in dimension will partly take the place of the sand tray. Where a blackboard cannot be obtained a yard of black unglazed American cloth stretched on thick cardboard or a small drawing-board will form an excellent substitute. Provide the child with a large overall, a duster, and some pieces of white and coloured chalks, and his happiness will be complete. One by one should the mother introduce a fresh form, and show her child how to improve his own productions.

Fröbel says: "Whatever a child already knows from what life gives and needs he puts into his drawing, examining and making it pass in review before his soul and mind as though to look it all over and to choose right and avoid wrong in the needs of his own future life."

Drawing is the step from mere looking at things to making a picture of them.

Blackboard drawing will be found to develop the æsthetic nature of the child much more easily and rapidly than ordinary drawing on slates and paper. The larger surface to be dealt with and the thick piece of chalk will tend to make the lines bolder and more graceful: the whole arm, instead of only the wrist and hand, is exercised; the amount of pressure required on the chalk will be likely to make the drawings decided and firm; while such great results are produced so easily and in such a short time that the child is delighted, and his interest will never flag. The drawing of flowers, leaves, animals, and objects will increase his observation; for he must look to find out all the details and parts most carefully before he can draw them. He will make many little discoveries, as for instance that many plants possess the same number of petals and stamens, that some leaves are round while others are oval, etc. Thus his knowledge of natural objects will be greatly increased; and his walks among the lanes and fields, his play in the garden, will have acquired an interest undreamed of before.

The following course was compiled for the benefit of mothers and teachers who are unable for various reasons to receive a systematic training in this important subject. Frequently I have heard students say, "It is impossible for me to draw; I have tried, but it is of no use." The reason of failure is generally this: they draw a man, a house, horse, cart, anything that comes into their mind first, or anything they can copy from a picture, without beginning with the simplest things and proceeding onwards gradually to the more difficult: they have, in fact, no method in their work, and it is practically useless. Half an hour spent every day at the blackboard will soon produce marked results. Another reason why the majority of drawings are so unsatisfactory is owing to the lack of observation on the part of the students: they see without seeing. Never lose an opportunity of examining

everything that may prove of value in your lessons: use your walks and holidays as so many opportunities for becoming more intimately acquainted with the beauties of nature; watch the ant at her work, the spider with her web, the habits and surroundings of the thousands of creatures that swarm around on every side, and I promise you a more entrancing book, filled with tales of domestic life, of tragedy, of love, than you ever found before.

There will then be no lack of subject for illustration; and let the delight and happiness of the little ones, and their appreciation of your efforts on their behalf, amply repay you for all the patience and steady perseverance you have given. You will then have aided in some way towards the carrying out of Fröbel's great summons to mothers and teachers: "Come let us live with our children, that all things may be better here on earth."

M. SWANNELL
Streatham, 1896

CIRCLE PATTERNS
PLATES I, II, III

IN commencing a systematic course of Blackboard Drawing, it is scarcely possible to find a better starting-point than the circle. Not only does the value of circle drawing lie in the fact of giving greater accuracy to the eye, but a thorough practice of it gives the pupil confidence in his own power of making the necessary large sweeps and curves, besides giving him greater power over the use of the chalk than does any other form. Then, too, just as Fröbel took the ball, the most perfect and simple solid and symbol of unity, for the first of his series of Gifts and Occupations, so may we take the circle, which is the simplest and most perfect of outline forms and figures, as the basis on which to found a graduated series of blackboard designs. Little children as a rule make their best symmetrical forms with circles. The drawing may be far from accurate, but the idea of symmetry has been found to be more marked and perfect when making use of circular forms rather than others. The pupil should not be allowed to stand too near the blackboard, for this would prevent him using the whole of his arm from the shoulder: care must be taken never to use only the wrist and fingers, as in ordinary drawing, or it will soon be found that the results are small and weak in outline instead of being large and bold.

The drawings should be as far as possible the result of the child's own thought and invention. For the first lesson or two the teacher might draw a simple pattern on her board for the children to copy; or she might give them the same centre for a pattern and let each child make what

4

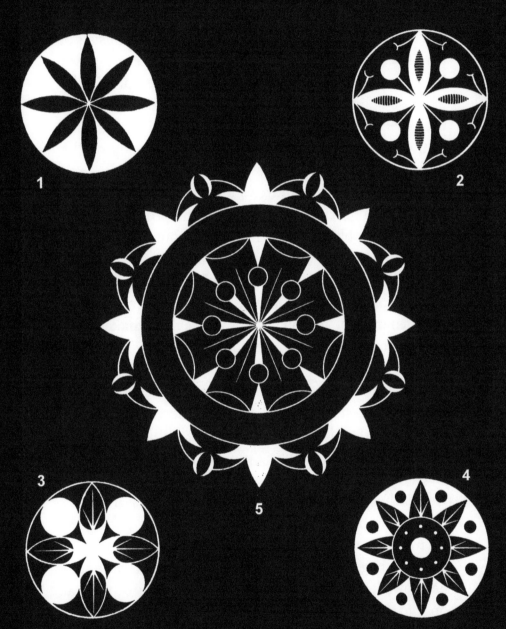

Plate I

additions he pleased, for sometimes children are a little afraid at first of working quite alone. Then, too, the rings may be used here with great advantage. For the benefit of those who are not acquainted with Fröbel's Gifts and Occupations, I will briefly describe this Gift. It consists of a number of metal rings whose diameter varies from two inches to half an inch. Each ring is cut in one place for the purpose of linking numbers together in a chain. Besides these are other half rings and segments. This Gift is used in the Kindergarten chiefly as an aid to developing the æsthetic nature of the children, but also for number and picture-making. The children should lay any symmetrical pattern with the rings and half rings and proceed to copy these on their blackboards. This will be found a great help in developing their powers of invention: in a little while they will not need the rings, but will be able to produce similar forms to those laid at their own pleasure. The children must never feel that they are able to make use of the teacher's brains whenever they find themselves in any little difficulty, or they will be unable to produce original patterns; but at the same time the teacher must be always ready to suggest and modify here and there. Frequently it will be found that children invent more difficult patterns than their limited drawing power can produce on the blackboard. The result then will be confusion and scribble. The teacher should do her best to find out what the child is thinking of, and endeavour to modify the pattern to such an extent as to bring it within his drawing capacities. From the beginning, "filling in" parts of the pattern should be allowed; for this gives a certain boldness perceptible at once to the child, although of course he would not be able to say so in these words, but would tell you "how pretty it is" or "it is a lovely pattern."

Children should be encouraged to find circular leaves and fruit, as the Indian cress, poppy heads, oak galls, etc., to take the place in their designs of simple circles.

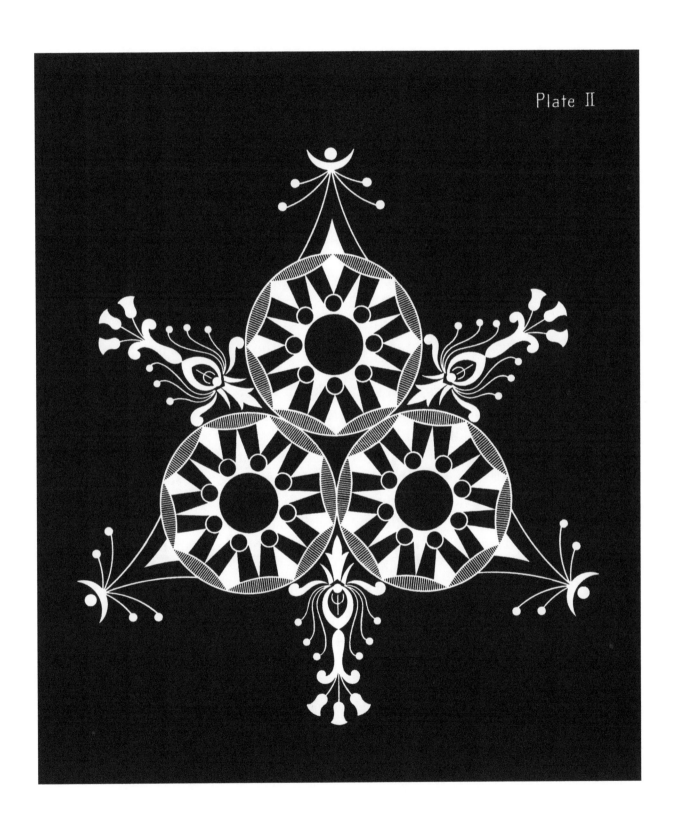

Plate II

The variety and number of patterns are endless, but they may be divided into two classes:—

 I. Those within the circle—Plates I and III.

 II. Those having one or numbers of circles as centres—
 Plate II.

It is always best to commence with the patterns formed within the circle. When once the large circle is drawn the design will be much easier than those belonging to the second division; and besides this, the drawing of large circles is more beneficial than the drawing of smaller ones. Having once obtained a fairly correct circle, let the child draw round the line three times to the left, then three times to the right, or vice versa, without once raising the chalk from the board. This will be a help to him in drawing circles freely and quickly in a short time. Above all, insist on the lines being very clear and distinct. The chalk will frequently break, but the child will soon find out for himself the best ways to hold it so that it will not break even when making very "white lines." The teacher must be careful to chat about the work occasionally in order to rest the child; for the little hands soon get tired, and are unable to press the chalk sufficiently to obtain the necessary firm clear lines, although the child himself will not be in the least weary of drawing.

On Plate XXVII is a photograph taken of a little boy's work at the end of one term's lessons. It is entirely his own invention, and when his teacher suggested a slightly different design he said he should like to think of one quite by himself. However valuable a long course of such patterns would be, it is never wise to continue them unbrokenly week by week. A flower or simple object suggested or brought by the child to be drawn will form a pleasant and useful break.

Plate III

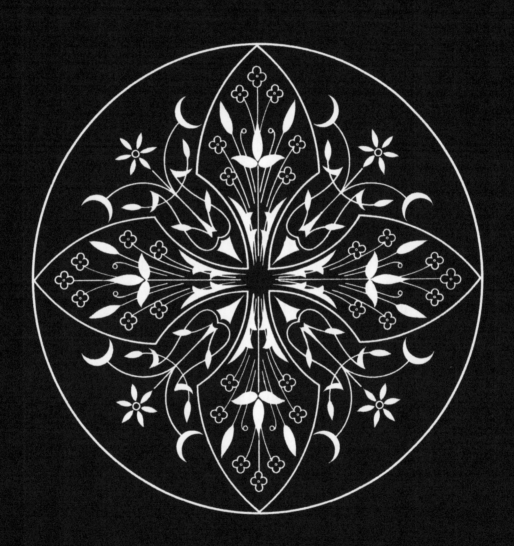

OBJECTS FROM THE CIRCLE
PLATES IV, V

THE drawing of objects is more suitable for very tiny children as a beginning than the patterns; for the idea of symmetry is not yet developed, as in the case of children of six and seven who have had a thorough training in the Kindergarten with the use of the Gifts and Occupations,—tablet-laying, paper-folding, paper-cutting, etc., or with children who, not having the advantage of attending a Kindergarten, yet are taught by a careful mother or nurse to draw in sand with a stick, on slates, paper, etc., and are shown how to use flowers, sticks, acorns, and stones in the formation of beautiful patterns and designs.

Then, too, the drawing of simple objects is a great help in the development of the observing faculty, besides appealing more closely to the little child's surroundings. It has been noticed that children of from three years to six or seven years of age always draw animals, flowers, or objects when left entirely alone, while those of seven years and upwards more often draw patterns than objects.

Circles of various sizes should be drawn clearly on the board: they must never be very small, or there will be no room inside for any markings that may be required. The first objects must be very easy, and obtained with the addition of the fewest possible amount of lines—*e.g.* an apple or cherry, as shown in the illustrations.

Each object should present a new feature of difficulty until the child is able to draw quite difficult objects, as the fish and gong (Plate V, Figures 1 and 4). In this, as in all other subjects, the great law of proceeding from

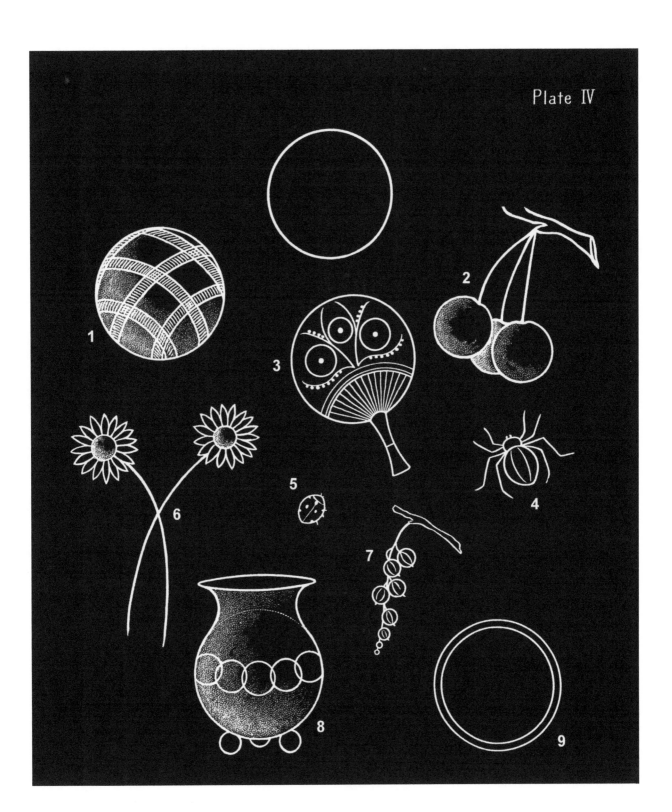

Plate IV

the known and easy to the unknown and more difficult must be kept in mind. The teacher should always let the children think of their own objects and draw them after careful examination of the thing itself. If the drawings are not correct, she must help the little ones from her board. It is of much greater benefit to the children to let them find out their own weakness for themselves; they will then be better able to appreciate and value their teacher's help. Coloured chalks may be used effectively, and will prove very valuable in teaching *little* children. Colour seems to inspire them at once. A tiny child was given a piece of white chalk and asked to draw an apple on the blackboard. She looked at the board, then at her chalk, and said she could not do it. Just then her eyes fell on some red and green chalks lying near, and, picking up these, she quickly drew an apple with a rosy cheek without any difficulty. She had only noticed the colour of apples, and not the form, and so was unable to imagine an apple drawn with white chalk alone.

Comparatively few natural objects are circular in form: with the exception perhaps of half a dozen leaves, the outlines of a few flowers, some fruits and seeds, all are more or less *oval* in form. No animals are entirely circular, although some may appear so at first sight to the little child, and do actually take this form at times—*e.g.* hedgehog, woodlouse, sunfish, etc.

The shading used occasionally in the illustrations is entirely for the use of students. It is not wise to let little children shade objects, as the idea is too difficult for them to understand; it is better to endeavour only to get true outlines.

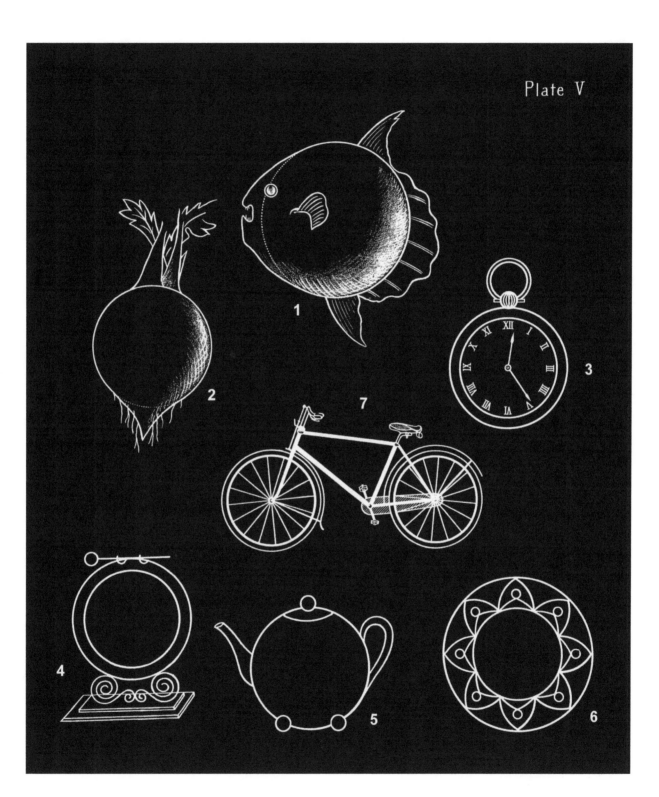

Plate V

OVAL PATTERNS

PLATES VI, VII

On Plate VI will be seen numbers of ovals of various shapes and sizes, also ellipses. Many people confuse these two names, or think that they both apply to the same thing. Such, however, is not the case. Oval comes from the Latin word *ovum*, an egg, and is therefore wider at one end, while an ellipse is alike at both ends, being the form a circle appears to take when seen either to the right or the left of the spectator.

There are many varieties of ovals: some may be long (Figure 5), others broad (Figure 6), while between these two may be drawn numbers of other ovals. The ellipse does not vary in form nearly as much as the oval; but we can have long narrow ellipses, short wide ellipses, etc.

Plate VI

OVAL PATTERNS
PLATES VI, VII

Begin first with quite simple patterns, using only the ellipse or oval, then combine the two as on Plate VII.

The rules given for circle drawing apply equally well to the drawing of oval patterns and forms.

Plate VII

OBJECTS DERIVED FROM THE OVAL
PLATE VIII

It will be far more easy to find objects having an oval than a circular form. Nature seems to have taken the oval as her ideal and striven to fashion each flower, leaf, animal, etc., as nearly after this form as possible. If examined carefully, it will be apparent that nearly all flower petals and leaves, many fruit and seed cases, fish, bodies of birds, insects, and some animals, resemble the oval very closely; so that it will not be a difficult task for children to collect numerous objects for this lesson.

The half oval is also to be met with very frequently: we see it in the mouse, rat, cup, wineglass, etc. Plate VIII furnishes a few examples of objects developed from these forms.

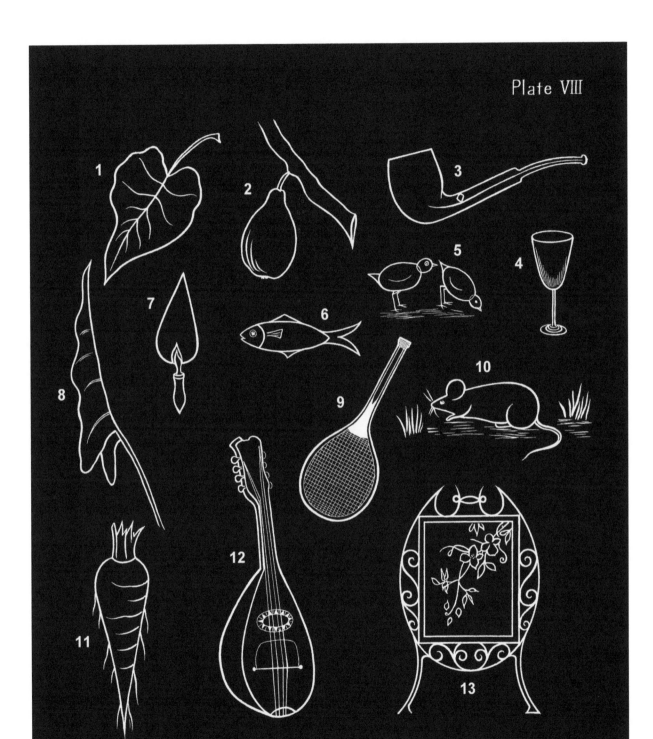

Plate VIII

SPIRAL FIGURES

PLATES IX, X

SPIRAL forms will be found most valuable in the development of patterns, as for example that on Plate X, as well as for such objects as shells, pea-pods and watch-springs.

The pupil must not be allowed to take his chalk up from the blackboard until the spiral is finished, and it will be found that the more rapidly spirals are drawn the better will be their form.

Figures 11 and 12 are examples of running patterns which children should always be accustomed to draw at the commencement of every blackboard lesson; for they seem at once to give them freedom, and confidence in the use of the chalk, and are an excellent preparation for long, continuous, and firm lines.

Figures 1 and 2 are the "watch-spring" spirals drawn two different ways: from left to right, and from right to left. Figures 3 to 6 show the spiral curves used in the formation of ovals which touch each other at one point on the circumference. In drawing these, the chalk must on no account be taken up from the blackboard.

Below these are various shells (Figures 13 to 17), all obtained from the spiral, parts of which in some cases have been rubbed out, as in the whelk shell. Oysters, mussels, cowrie shells, razor-fish, are obtained more easily from this form than from any other.

Plate IX

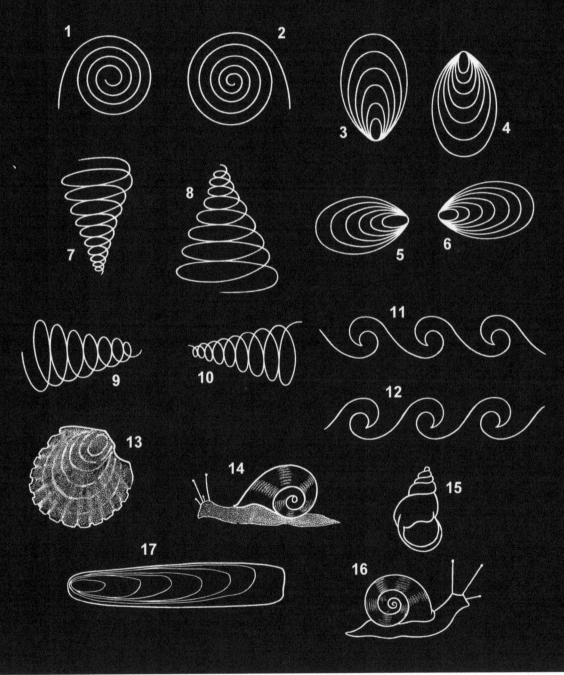

SPIRAL FIGURES

PLATES IX, X

SPIRAL forms will be found most valuable in the development of patterns, as for example that on Plate X, as well as for such objects as shells, pea-pods and watch-springs.

Plate X

COMMON OBJECTS

PLATE XI

In drawing common objects, many people find considerable difficulty in making both sides alike, or in getting the right proportions between the height and the width; they will therefore find help by drawing such objects within a regular figure as an oblong or triangle. The proportion of the triangle should be as follows:—

Draw a line DC any length, which will constitute the altitude of the triangle. At right angles to this draw a line AB, the base of the triangle, which shall be equal to the line DC. Join AC CB. Find a point in the line of altitude which shall be about the height of the required object, and through this draw a line parallel to the base line, meeting the two sides of the triangle. Round this line describe an ellipse, and draw lines parallel to the line of altitude from the ends of the ellipse. Draw a curved line for the base outside of the triangle, parallel to the bottom line of the ellipse (Figure 2). The base line should, strictly speaking, be rather more curved than that at the top. The reason of this can easily be shown to the children. Take a cup or jar, and hold it up so that the top is a little above the children's line of sight. Gradually lower it and the ellipse at the top will appear to become more and more circular, until, when the cup rests on the ground, a perfect circle will be seen. Children will easily reason from this that the lower line should be more circular than the upper.

Some objects, as a pail (Figure 7), waste-paper basket, tub, etc., are more easily drawn in an inverted triangle, the proportions of which do not vary. All kitchen and cooking utensils, plates, cups and saucers, teapots, etc., will be very easily drawn when using the triangle.

Plate XI

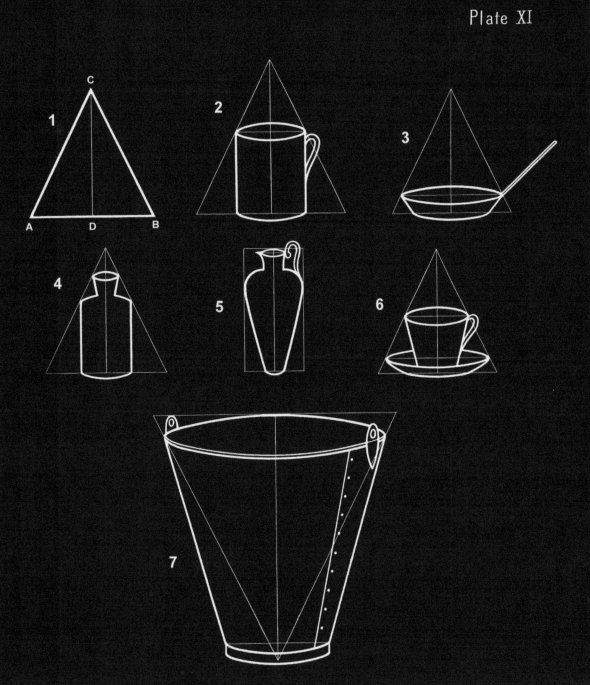

FISH

PLATE XII

FISH, more than any other animal, take the form of the oval, and are among the easiest examples for children's drawings, since, with the addition of tail, fins, and eyes, the oval is converted into a fish, which in the vivid imagination of the child swims and moves about in the water. To him it is no picture, but a real, living fish which he has created and loves. I have seen children almost cry when, perhaps after half an hour's steady work, the teacher has rubbed from the blackboard the bird or fish they felt such pleasure in making.

It is very difficult for grown people to imagine that what are pictures and lines to them are living realities to the little child.

1. OVAL.

2. FISH, AS CHILDREN DRAW THEM.

3. FLYING-FISH.

4. HADDOCK.

5. PERCIL.

6. NOCTILUCA.

7. SHRIMP.

8. TURBOT.

9. JELLY-FISH (MEDUSA).

10. TUNNY.

11. JELLY-FISH (LIZZIA).

12. CRAB.

13. ZOA, OR BABY CRAB.

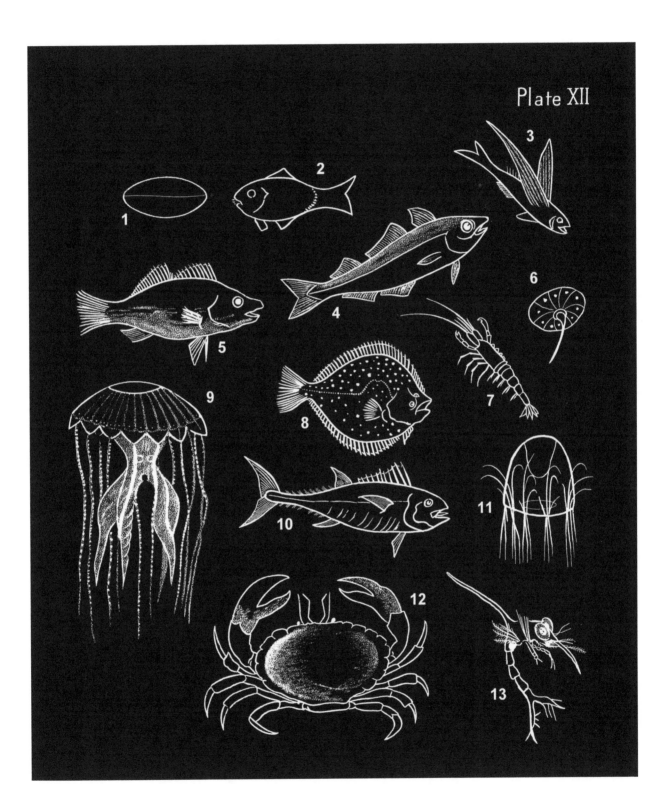

Plate XII

The best way to draw fish is thus:—Make a straight line (not too short) on the board, and round this describe an oval, the lower part of which shall be deeper than the upper part; for if a fish should be cut in two from the middle of the tail to the middle of the head, the lower part would be much deeper than the upper.

To the oval drawn add tail, fins, eye, and mouth (Figure 2). In the case of jelly-fishes (Figures 9 and 11), only half ovals will be needed.

The chief part of the crab (Figure 12) consists of a large, broad oval, to which at the smaller end are attached four pairs of claws. Where possible, let the children have a living fish to examine before commencing to draw. Be careful to notice all peculiarities, such as the spines of the stickleback, the long skin appendage to the cod's mouth, the tentacles of the jelly-fish, and the two eyes on the same side of the flat-fish. Tell their use, and how they came to differ through their mode of life, and besides the mere mechanical drawing you will fill your children's minds with the knowledge of the beauties and wonders of the life around them, and do your part towards making the period of childhood a bright, happy memory in future years.

1. Oval.
2. Fish, as children draw them.
3. Flying-fish.
4. Haddock.
5. Percil.
6. Noctiluca.
7. Shrimp.
8. Turbot.
9. Jelly-fish (Medusa).
10. Tunny.
11. Jelly-fish (Lizzia).
12. Crab.
13. Zoa, or Baby Crab.

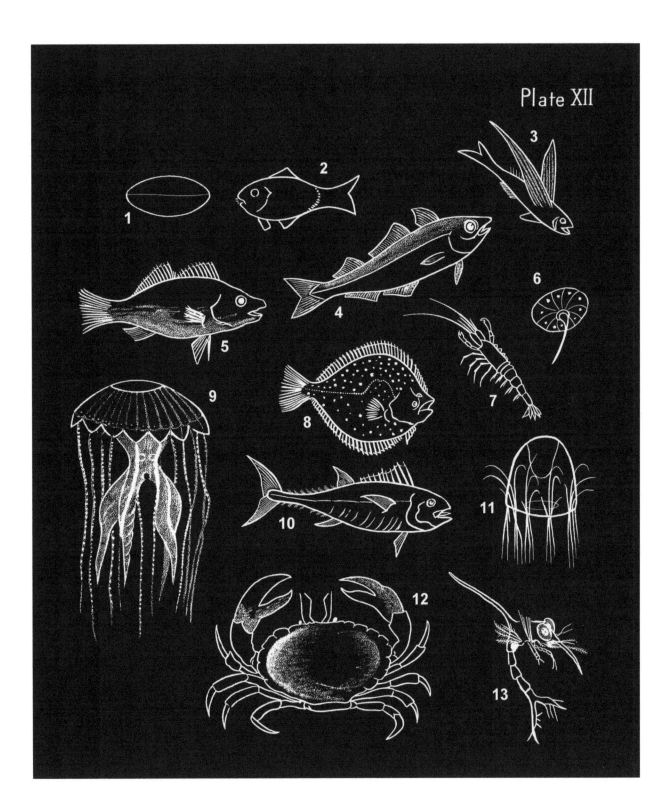

Plate XII

LEAVES—TREES

PLATE XIII.

ALTHOUGH the majority of leaves are obtained from the oval, there are some which may be more easily classed under a different name. For instance, the ivy leaf is more pentagonal than oval. Then, too, all leaves are not simple like the elm, but have three or more leaflets, which are generally oval, attached to a central stalk to form one leaf, as the rose, blackberry, walnut, etc.

Therefore leaves fall easily into two great divisions:—

I. Simple.

II. Compound.

The shape of leaves varies considerably. The chief are:—

1. *Round.*—Comparatively few leaves belong to this class, and they are difficult for children to find. A few examples are:—the Indian cress (Figure 4), nasturtium; cucumber leaves too, and the hazel, appear more circular than oval.

2. *Oval.*—By far the greater number of leaves belong to this class, and nearly all the leaflets of the compound leaves are oval, as the blackberry, clover, the giant rhubarb, outlines of ferns, lilac, elm, oak, laurel, even grass leaves—all these are oval, although some, as the grass, may be difficult to recognise as such at first.

3. *Triangular.*—These might almost be included with the oval leaves, but there are a few whose outlines seem such perfect triangles that I have thought it better to class them under this name for the sake of clearness. Such are the stinging nettle, black poplar, and silver birch.

1. SWEET PEA.

2. SYCAMORE FLOWERS.

3. WILLOW.

4. INDIAN CRESS.

5. OAK.

6. NETTLE.

7. HORSE-CHESTNUT.

8. HAZEL CATKIN.

9. LIME.

10. WYCH ELM.

11. IVY.

12. FIR.

13. CONVOLVULUS.

14. SYCAMORE SAMARA.

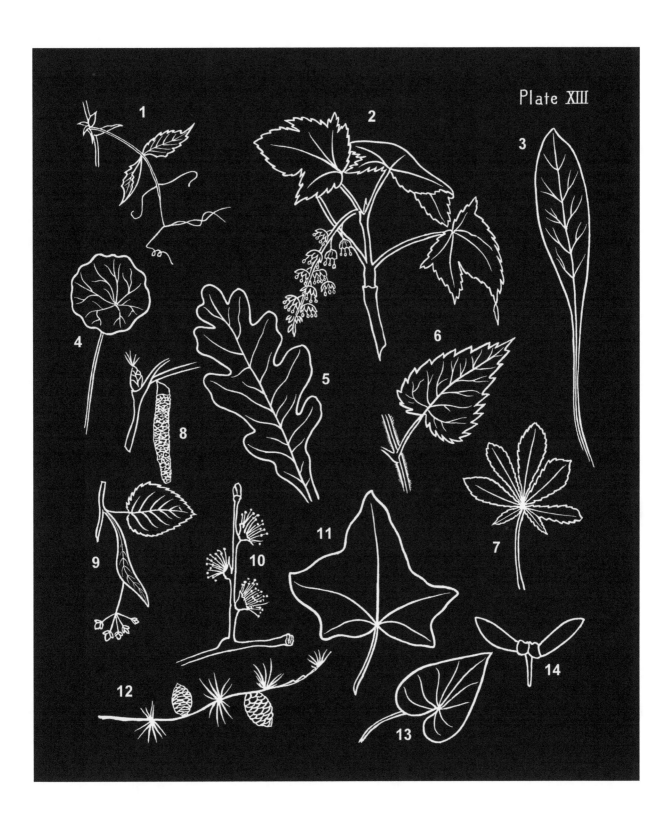

Plate XIII

4. *Pentagonal.*—This class is also a small one: to it belong such leaves as the ivy, plane, sycamore, and deadly nightshade.

5. *Needles.*—Many of the sharp, thin fir and pine leaves can scarcely be called oval: all these may be classed under one term—"needles."

While speaking of leaves, it may be as well here to make note of a few facts concerning trees in general. All trees, when fully grown, if not damaged when young by chopping or bruising, and if not planted closely together, take the form of their leaves. Thus the shape of the lime tree is a perfect oval, and the curious branchings of the oak give it an appearance exactly resembling its own leaf. It is quite easy to some people well acquainted with leaves to recognise any tree at a long distance away. Again, the branches of trees correspond exactly to the veinings of the leaves. If the veins are alternate, the branches will be found to grow alternately; if the veins are opposite, the large branches are opposite. Every curve in the branch, even to the tiniest curve of the twigs, is that of some part of the oval, either one half or quarter. Blackberry brambles, dog-roses, nearly all the climbing plants in the hedges, take the curve of the oval in their growth and development. In drawing trees on the blackboard , draw the trunk first, and put in the branches with double lines leading away from the trunk; rub out that part of the trunk between the two lines of the branches; draw smaller ones leading out from the chief branches in the same way; then, using the long side of your chalk, draw quickly a few broad waving lines round your skeleton tree, add a few small branches in the midst of the foliage, and the tree is complete. Be careful always to make the trunk and branch lines very

clear and decided, while the leaf part should be light and more indistinct in parts. Keep in mind the shape of the tree and the position of its branches. A leaf of the particular tree you are wishing to draw held in your hand will give all this necessary information. When drawing only single leaves, make the outline very clear and firm and the veins fine. Do not allow the children to draw in the veins indiscriminately: let them examine the leaf most carefully before they draw. Notice whether the leaves are notched or smooth, and whether the notches are large or small; then, too, never forget to draw in any tendrils or leaf appendages which may form a characteristic feature of the plant, as in the sweet-pea (Figure 1).

I strongly advise students to make a collection of leaves of common trees and plants; because, even when pressed, the characteristics of the leaves are preserved, and will be found most useful, especially in the winter when it is so difficult to find natural objects for the drawing lesson. Besides, such a collection forms an excellent key to the characteristics of the different trees from whence they come.

BIRDS

PLATES XIV, XV

THE bodies of birds, like those of fish, are almost a perfect oval in shape; and the simplest way for children to draw birds is that shown on Plate VIII, Figure 5, where an oval represents the body, a smaller one the head, and these, with the addition of a tail, beak, eye, and legs, form quite a pretty little chicken. On Plate XXVII is the photograph of some chickens drawn by a little boy three and a half years old in this simple way. Gradually fresh features of difficulty may be presented, until the child is acquainted with at least one of each kind of birds.

Birds may be divided into six chief groups:—

1. *Perchers.*—Those with small bodies, sharp-pointed beaks, and feet with three toes in front and one behind, as in Figure 3. Examples:—goldfinch, linnet, sparrow, robin, and nightingale.

2. *Climbers.*—Having a foot with two toes in front and two behind, strong beak, and widespreading tail, as the woodpecker and parrot.

3. *Waders.*—With long legs, and often webbed toes, as the flamingo, heron, stork, snipe, oyster-catcher.

4. *Swimmers.*—Having strong webbed feet well set back on their boat-shaped body, thus giving them an awkward waddle when on land, as the duck, goose, sea-gull, etc.,

1. GOLDFINCH.

2. LINNET.

3. FOOT OF PERCHING BIRD.

4. OSTRICH FOOT.

5. OSTRICH.

6. SEA-GULL.

7. WOODPECKER.

8. FLAMINGO.

9. VULTURE.

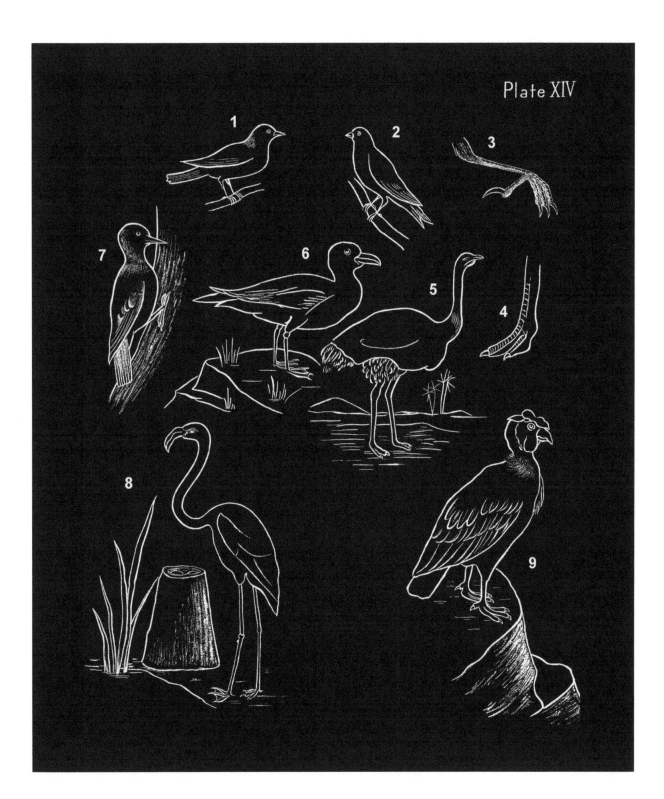

Plate XIV

5. *Runners.*—Possessing long and very strong legs, with two or more toes (Figure 4), as the ostrich, cassowary, apteryx.

6. *Scratchers.*—As the common fowl, partridge, and bustard.

The birds of prey are characterised by their hooked beaks, powerful wings, and often bald heads, as the vulture and eagle.

While examining the birds preparatory to drawing them, children should be led to notice all these different facts.

Plate XV shows the principal positions of birds' wings when flying: the birds are not in proportion to one another, as the drawings merely illustrate this fact. In drawing birds' wings, great care must be taken to put in the position of the joints accurately: do not make the wing one continuous curve.

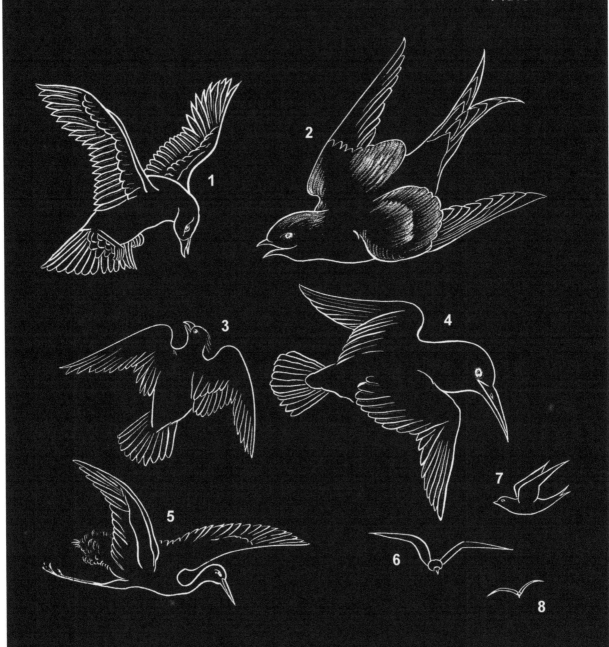

Plate XV

FLOWERS

PLATE XVI

VERY little more can be said regarding the drawing of flowers than has already been stated about leaves. It is most important that the outline be quite clear. Do not attempt to rub out with your fingers, but use a damp duster, or the drawing will be spoiled. Nearly all flower petals are oval, so that the children will feel they are dealing with an old friend under a new aspect. When wishing to colour the flowers, let the outline always be drawn first with white chalk, for a far better effect is thus obtained.

Many flowers have distinct lines running up the centre of their petals like veins. The clematis, for instance, has three or four most decided veins of a dark colour running from base to apex. With older children of eleven and twelve years, shading may be allowed. It can be taught much more easily with the blackboard than in any other way, on account of the facility with which any errors may be rubbed out.

For little children it is best to keep to plain outlines. When the flowers are not large, the whole plant should be drawn. Children should be shown that many plants have quite different leaves near their roots to those found on the stems. When there are bracts attached to the flower stems, as in the case of the bluebell (Figure 5), or lime (Plate XIII, Figure 9), they should be drawn in carefully. Do not give little children small flowers, such as the may and buttercup, to draw; for they find it almost impossible to enlarge a flower, and so would not get the necessary practice. But with older children a small flower would form an excellent exercise in enlarging and in testing their observation.

Such flowers as daffodils, narcissus, wild roses, dog-daisies, are the best for quite little children.

1. LABURNUM.

2. ARUM LILY.

3. DAFFODIL.

4. WATER CROWFOOT.

5. BLUEBELL.

6. HAREBELL.

7. MOON DAISY.

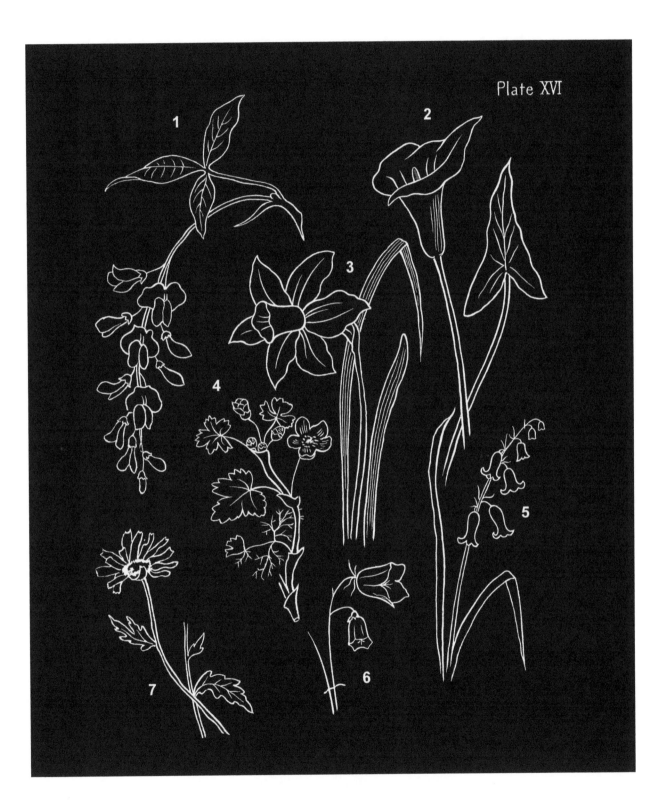

Plate XVI

INSECTS

PLATE XVII

In drawing insects, spiders, etc., the body must be the first point to be noticed—whether the abdomen be long or short, thick or thin; whether the thorax be joined closely to the abdomen or separated by an apparent thread, as in the wasp. Then draw three ovals—generally long and thin for the abdomen; a second, just above this, shorter and wider for the thorax; and a much smaller but wider one still for the head.

The wings and legs are always attached to the thorax: never to the abdomen, where so many students place them if they cannot find room for one of the pairs of legs perhaps. Students must be careful to remember the distinctive marks of each class of insect: the balancers of the gnat tribe (Figure 1), the peculiar gauze wings attached so low down on the thorax of the dragon-fly family, the thin long antennæ of the butterfly, and the feather-like antennæ of the moth. They should endeavour to acquaint themselves with the homes of the common insects and spiders; for children are always very interested in hearing about the homes of all the creatures they see, and when impossible to obtain the real home, drawing becomes invaluable. Figure 3 shows the fairy-like home of the tent-maker moth, of which the little ones never tire of hearing; and in Figure 15 we see the thimble-shaped nest of the water spider. Stories of the metamorphosis of insects form the most intensely interesting fairy tales to the little ones, and their delight is boundless when such descriptions are illustrated by the simplest drawings. What, for instance, can be more fascinating than the story

1. DADDY LONG-LEGS.

2. CRICKET.

3. COCOON OF TENT-MAKER MOTH.

4. DRAGON-FLY.

5. BUMBLE BEE.

6. WATER BOATMAN.

7. CADDIS WORM.

8. LADY-BIRD.

9. BUTTERFLY.

10. BEETLE.

11. MAY-FLY.

12. BUTTERFLY (2ND POSITION).

13. CATERPILLAR.

14. MOTH.

15. WATER SPIDER AND NEST.

16. GRASSHOPPER.

Plate XVII

of the wonderful cicada who, in its larval state, lives for seventeen years under the ground among the roots of trees, after throwing itself down to the ground from the top branches?

Children very seldom forget a well-illustrated story or lesson: it becomes thenceforth a part of their lives. In Figure 7 is seen a caddis worm, one of the simplest kind to draw: but some caddis make most complicated and beautiful homes out of pieces of grass laid with great precision in regular geometric forms; others, again, ornament their sand cases with shells, pieces of sealing-wax, or any coloured material.

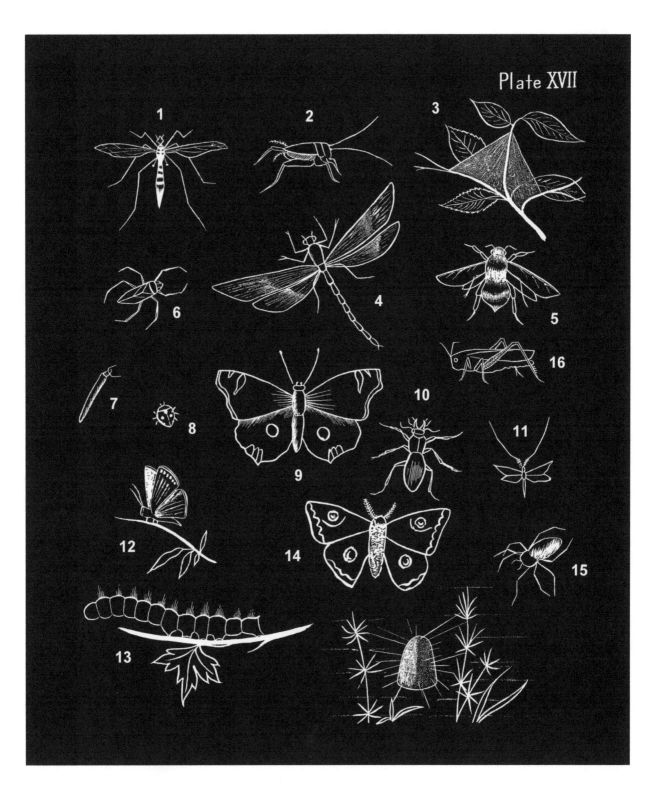

Plate XVII

LEGS AND ARMS
PLATE XVIII

THIS subject will doubtless appear very strange for a black-board drawing lesson. It is, however, not intended for the use of children, but only for students and teachers who find a difficulty in drawing animals. The drawings are not anatomically perfect, but the principal bones, their joints and directions, are all that will be needed for our purpose.

I have seen so many animals drawn whose legs are destitute of the least suspicion of a joint, and looking more like kitchen table-legs than anything else. After trying various ways in order to impress the necessity for leg joints, it was suggested that a lesson on the bones of typical animals might prove valuable; and, however uninteresting such a subject may appear, I cannot too strongly recommend a thorough trial of it. In Figures 1 and 2 are the leg and arm bones of a human being, and the same terms are applied to all the others in order that there may be no confusion. The same letters also apply to the same parts, thus:—

Leg Bones.—A corresponds to the thigh.

B corresponds to the knee.

C corresponds to the ankle.

Arm Bones.—H corresponds to the shoulder.

E corresponds to the elbow.

O corresponds to the wrist.

1. MAN'S LEG BONE.
2. MAN'S ARM BONE.
3. MONKEY'S LEG BONE.
4. MONKEY'S ARM BONE.
5. HORSE'S HIND LEG.
6. HORSE'S FORE LEG.
7. LEG OF WALRUS.
8. FRONT FLAPPER OF THE WALRUS.
9. BAT'S LEG.
10. BAT'S WING.
11. BIRD'S LEG.
12. BIRD'S WING.
13. HIND LEG OF THE TORTOISE.
14. FRONT LEG OF THE TORTOISE.

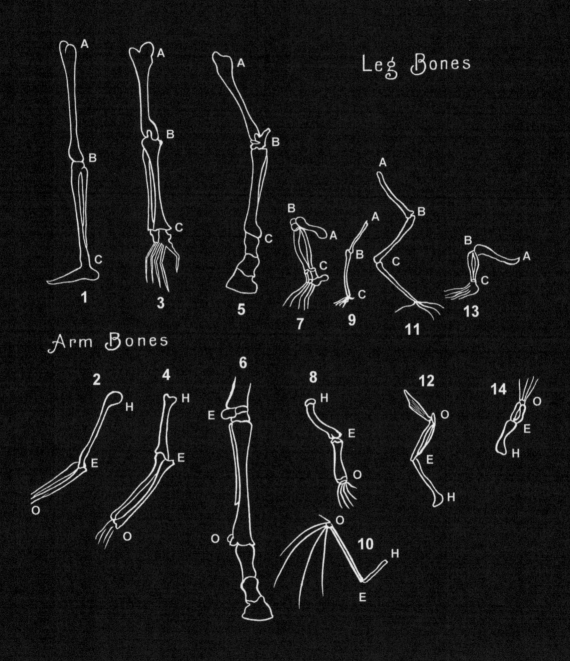

Plate XVIII

Leg Bones

Arm Bones

It is very interesting to note that in the higher animals, reptiles, birds, and even in some fish, similar bones to those of the arms and legs in man are found, although a casual glance would not suggest any such similarity. For instance, Figure 11 shows the leg bones of a bird.

The thigh bone AB is enclosed in the body, and therefore invisible; the knee bone BC corresponds to the bone from our knee to ankle; while from C downwards is shown the bone corresponding to that of the sole of our feet, so that the bird really walks on its toes, which have become adapted to its mode of life through long generations. Figure 10 is the skeleton of a bat's arm, which has developed into a curious wing; the bones corresponding to our fingers supporting it, while the small bone at O resembles our thumb. A careful study of these bones will enable the student to keep from falling into the common error of drawing jointless animals.

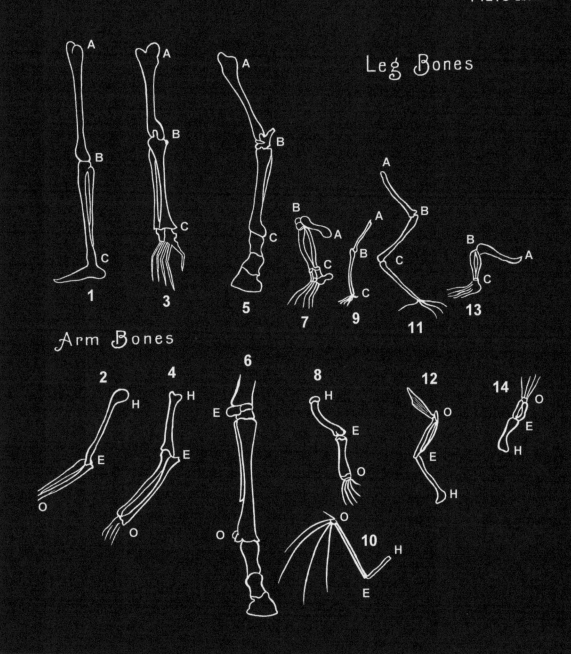

Plate XVIII

Leg Bones

Arm Bones

ANIMALS

PLATE XIX

WITH the knowledge of the position of leg and arm bones furnished by careful study as directed in connection with Plate XVIII, the student will find comparatively little difficulty in determining the form of any animal. Her observation will have shown the length and approximate size of the bodies of the more common animals, and with the help at first of some good pictures and photographs it will not be long before she is able to draw any animal likely to be required in illustrating stories and lessons. Instead of drawing the bones fully, faint lines will be quite sufficient to indicate the position of the legs. These lines will then only need to be clothed with flesh, and in regard to this a general rule may be observed—below a joint the muscles are very prominent and full, while they decrease in fulness and amount until their minimum is reached immediately before a joint; the muscle too, as a rule, is behind the bone and not before, *e.g.* the "calf" in a man's leg diminishes so much that the leg above the ankle is little more than a thick skin-covered bone.

It is useful sometimes to make a list of animals with long bodies, like the weasel and ermine, reindeer, etc.; and short, like those of the elephant and sheep: those in whom the body underneath presents a convex appearance, as the horse, donkey, cow; and those apparently concave, as the greyhound, toy terrier, stoat, etc.

Many animals have quite straight backs and necks, as the cow and pig; others, again, present a graceful curve, as the horse, ass, dog, lion.

48

Plate XIX

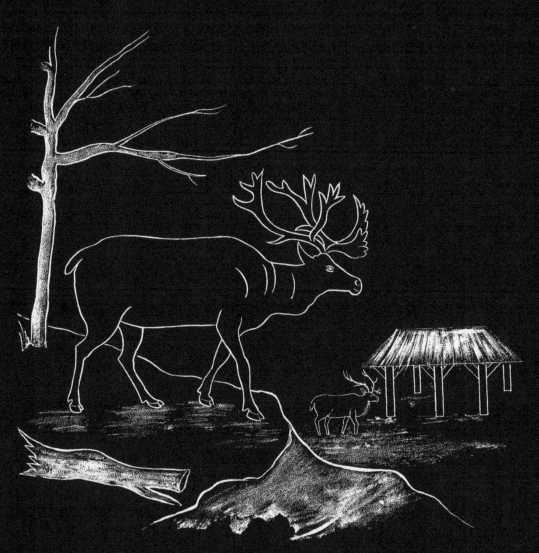

Winter Shelter

The feet, too, offer another feature worthy of special notice; some being hoofed (horse, ass, zebra), some cloven (cow, pig, antelope), others padded (cat, lion, tiger, panther), others again possessing non-retractile claws (dog, dingo, rabbit, bear).

Again, the special features of the head and face of various animals must be noted. The student will doubtless discover such for herself. All these points, however insignificant they may seem, will yet prove of the greatest use when practising the drawing of animals. The following figure has been found to help many students in finding the right position of the limbs when the animal is in motion, as in galloping and running.

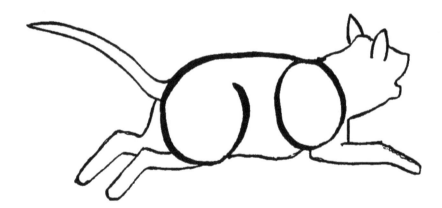

Plate XIX

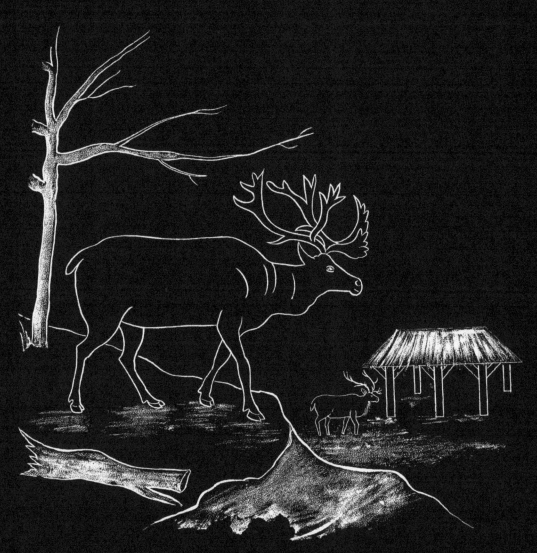

Winter Shelter

SHADED OBJECTS

PLATE XX

THE shading of objects is not suitable for very little children, as it is exceedingly difficult for the teacher to explain and for the children to understand the reason why they should make some parts of their drawing dark and others light, especially as their perceptive powers are not keen enough to see such shades on the object before them unless the sunlight is very strong. Shading should therefore be reserved until a later period, when the children will have acquired some considerable skill in drawing outlines. No shading must be attempted until the outline is as perfect as the child can make it. Many people shade with a view to hiding such defects; but instead of hiding them, shading generally brings these defects into far greater prominence. Begin by chalking over the object drawn as lightly as possible. Do not let the child press heavily on his chalk at first, or the result will be one even thick coat which will admit of no further shading, as in Figure 2, where an otherwise beautiful vase is entirely spoiled by careless "filling in."

In every solid object there must be one side very dark and the other side very light, while between these two is an even gradation of shades: the side, of course, nearer the light will be the lighter. It must be remembered too that every handle, every raised ornamentation, however slight, has its light and dark sides, while immediately beneath any overhanging rim or raised part the surface of the object will be in deep shadow.

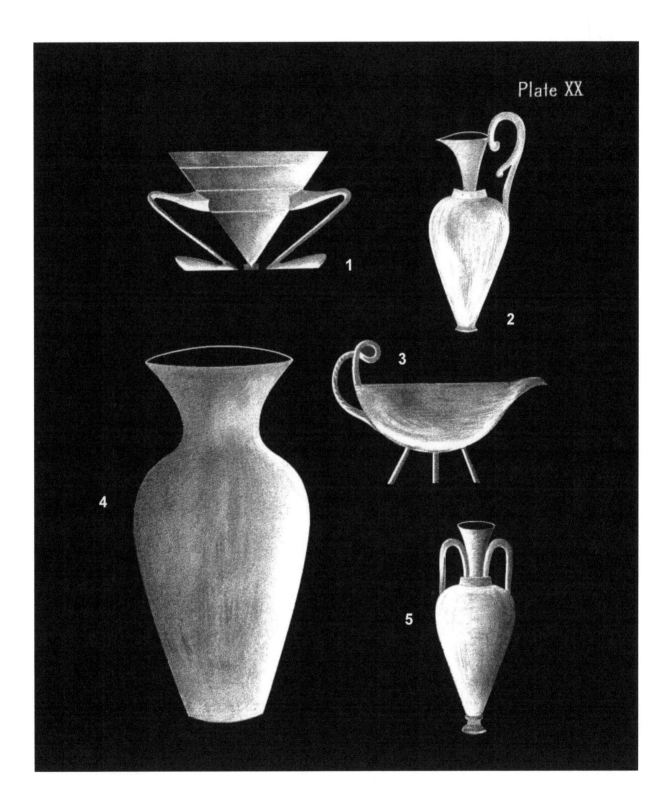

Plate XX

MODEL DRAWING

PLATE XXI

In the illustration a Japanese bamboo flower-stand has been chosen as a model, but the following remarks apply equally well to all models—chairs, tables, desks, houses, etc.

The pupil must never stand directly in front of any model, because in that case only one side will be seen: it is best to place the object with one corner facing you, so that two sides of the four legs may be seen. The first thing to be done is to draw an upright line corresponding to the corner of the stand or table nearest your blackboard. Fix the height accordingly as you wish the drawing to be large or small. Next measure the angles BAC and BAD. Holding out the chalk in a horizontal position at arm's length, shut one eye, and cover the angle at A with the end of the chalk; you can then see whether the line AC appears to fall above or below the chalk, and how much. If the object is above the line of sight, the lines will fall below the chalk; if below, the lines will appear above.

Draw carefully the exact position of the line as you see it (Figure 2). Next measure the line AD in the same way (Figure 3). When the position of these two lines is obtained, the most difficult part of the drawing is over. At present we have only the direction of the lines AC and AD; we must now find their lengths. Hold the chalk at arm's length, shut the same eye as before, and measure the apparent length of the line AB: it may be two or three times the length of the chalk. Next turn your chalk in a

Plate XXI

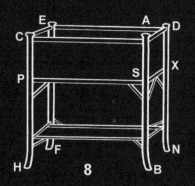

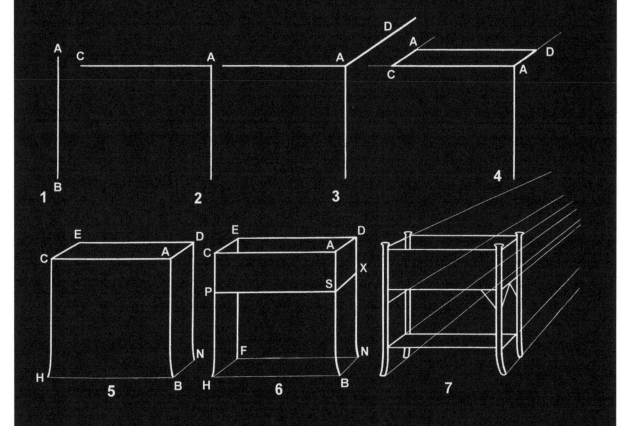

horizontal position on the same plane, and find out how many times the length of the chalk is contained in the apparent width of the line AC. Mark carefully the results of this measurement on the blackboard. This process is, roughly speaking, measuring the height into the width. Find the length of AD in the same way, taking care always to keep the chalk in the same plane for measurements. The farther away from you an object is, the smaller it must appear. For instance, on looking at railway lines, you know they are parallel, yet they appear to meet at a point on the horizon. Just so must all the lines of the drawing, if produced far enough, meet at a point. These are spoken of as converging lines. All the lines in the drawing running in the same direction must converge. In order to obtain the lines DE and EC, make DE converge slightly towards AC, and CE towards AD. (Figure 4). The meeting-point of these lines will give the position of the leg EF. Figure 5 shows imaginary lines HB and BN drawn converging with those forming the top of the stand, and perpendiculars drawn from points C and D will give the legs CH and DN.

Find the lines HF and FN in the same manner as CE and ED, and draw EF.

On AB measure to find the position of the lines PS and SX (Figure 6).

Figure 7 shows the completion of the legs and the bars connecting the legs, while the finished stand with its double lines is seen in Figure 8.

Plate XXI

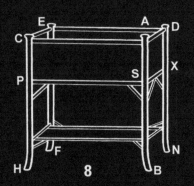

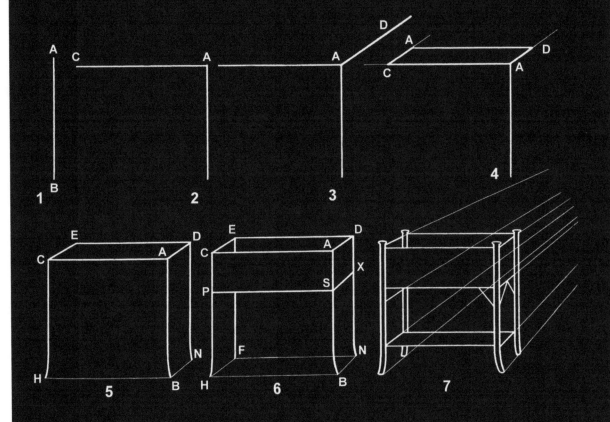

THE HUMAN FIGURE
PLATES XXII, XXIII

THE drawing of the human figure is the most difficult of all; but if the various proportions are thoroughly understood, it need present no insurmountable difficulty. The student must not expect great results at first, nor need she feel disappointed if her figures look stiff and uncomfortable and resemble wooden Dutch dolls or Noah's Ark people. Gracefulness of form only comes through a long and thorough practice. A few visits paid to the National Gallery, or any place where there are pictures dealing with the old Roman and Greek styles of dress, will prove most beneficial; for the olden style is far more graceful than is the fashion of to-day. It is much better for beginners to confine themselves to the flowing draperies of past ages, if they desire gracefulness and freedom in their pictures later on.

Never neglect an opportunity of drawing on the blackboard during the lessons: however crude and un-satisfactory the drawings may appear to you, the children will be delighted, and will thoroughly appreciate any effort. Never mind if they be so unsatisfactory that you feel "it is no use trying to draw," you have "no talent in that way." For the children's sake persevere. There never yet was a student who determined by thorough, conscientious work to gain a certain goal, cost what it might, who did not in the end win it; and if only teachers would realise what a wonderful part drawing plays in the education of little children, there is no one who would not devote her spare moments to the cultivation of this faculty.

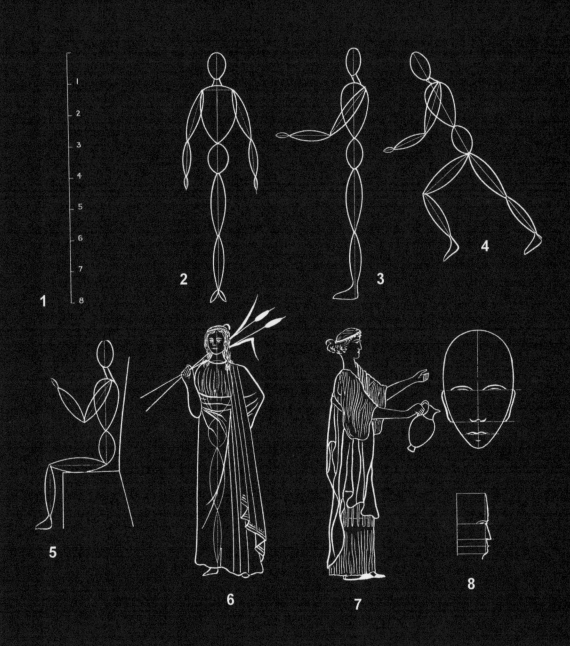

Plate XXII

The proportions of the human body may be obtained by dividing a line into eight equal parts (Figure 1). One part represents the head; half a part, the neck; one and a half parts, the chest; one part, the abdomen; two parts, from the thigh to the knee; one and a half, from the knee to the ankle; and half a part for the feet. The length of the arm to the elbow should be that of from the shoulder to the thigh. From the elbow to the wrist the distance should be equal to one and a half parts.

Having divided your line thus, draw ovals round each part, as in Figures 2 and 3, and you have a skeleton ready to be dressed as you please. Children delight in drawing these figures and dressing them just as they do their dolls. Figures 4 and 5 give the position of the body when bending forwards and sitting; it is unnecessary to further explain them. Figure 6 shows one method of dressing a full front figure; while Figure 7 shows a side view from which all the foundation lines have, when finished, been taken. In drawing the head certain definite proportions are taken. Draw an oval. Divide it in halves with a faint line. On this line draw the eyes. Halve the lower part of the face, and the second line will give the position of the nostrils. Half of the lower part again will show the position of the lips. The base of the ears should be on a line drawn at right angles to the nostrils. Figure 8 shows a side face drawn in an oblong, but an oval may be used equally well: the proportions are just the same.

Plate XXIII

ILLUSTRATIONS FOR NUMBER LESSONS
PLATE XXIV

ALTHOUGH the blackboard is considered almost indispensable in teaching Arithmetic, it is very seldom used in making pictures for the Number lessons in the Kindergarten and Infant Schools, where it is, if possible, more needed. Little children are only able to realise the value of numbers when connected with concrete things, and the blackboard offers at all times an excellent supplement to the number exercises given with the various Gifts and Occupations.

On the accompanying Plate a few suggestions are offered for illustrating the first ideas of number; other examples may be made in endless variety.

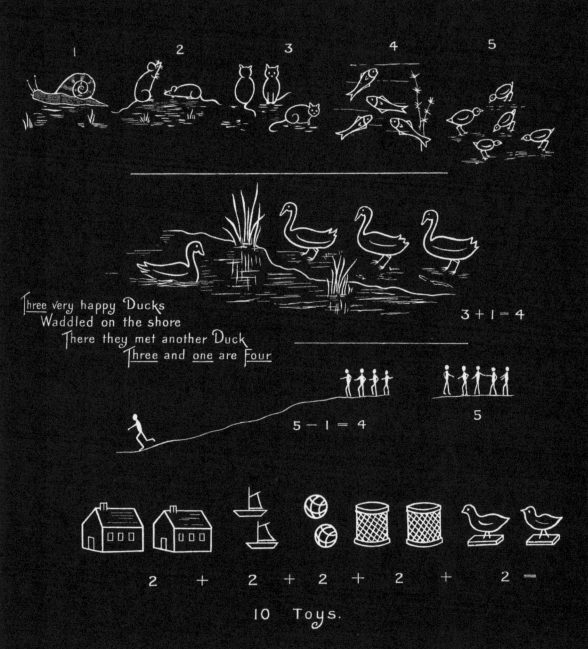

Plate XXIV

1 2 3 4 5

Three very happy Ducks
 Waddled on the shore
 There they met another Duck
 Three and one are Four

3 + 1 = 4

5 - 1 = 4

5

2 + 2 + 2 + 2 + 2 =

10 Toys.

ILLUSTRATIONS FOR
GEOGRAPHY LESSONS
PLATE XXV

THE illustrations on the accompanying plate are intended to be used in giving lessons on the "Action of the Sea on the Coast-line," to children about the age of six or seven.

After making various simple experiments with sand, stones, and water, showing how water poured from a height has such power that it is able to displace the sand and make holes and rough places, leaving the stones exposed, the children will readily understand how the sea is able to wash away the soft parts of the coast and leave behind the hard rocks, as in Figure 1. The teacher will enlarge on the dangers to ships from these rocks, and the children will at once suggest the need of some warning to ships to keep away from them. Then will follow the history of the lighthouse. Figure 2 is a bay where the surrounding rocks have been soft enough for the sea to wash them away and flow on to the land. Every geography lesson given to little children can be easily illustrated, although teachers often avoid the blackboard most carefully on such occasions. The picture of any one thing mentioned will be quite sufficient to enable children to remember the lesson for a long time. Beautiful pictures of mountains, springs, waterfalls, and rivers can be drawn in a few moments. At a lesson given on Volcanoes, the teacher had a group of mountains drawn on the blackboard, one of which was larger and more prominent than the others—some had their tops covered with snow, while lower down, patches

Plate XXV

Geography

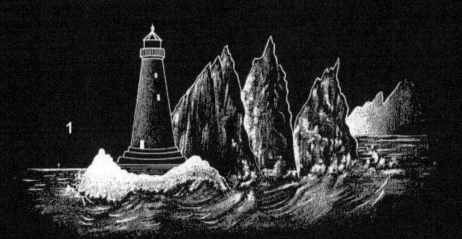

Light-house

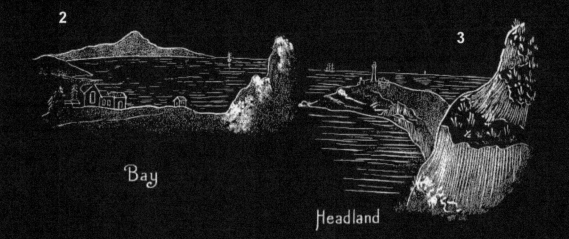

Bay

Headland

of green, brown, and yellow chalk did duty for forests, fields, and vineyards. After describing the mountain scenery and the life of the mountaineers, she told how one day they heard great noises under the ground and the earth seemed to shake a little, and at last suddenly at the top of the snow-covered mountain a great flame of fire, in the midst of which were huge stones and ashes, shot up to a great height in the air. At the same time she accompanied her words by quickly rubbing out the "snow" and drawing with bright yellow and red chalks the column of fire with its smoky cap and the great streams of lava running down the mountain sides. The children called out with delight, and afterwards whenever a volcano was mentioned in their presence they begged their teacher to draw them another, nor would they allow her to forget a single patch of field or forest and the roads running round the mountain's base. It was a very easy drawing, but the effect on the children was so great that they would never forget a volcano.

With the tiny babies in the Kindergarten the first ideas of place are given by means of such stories as that of Robinson Crusoe. These lay the foundation for future teaching in geography, and are rendered far more valuable by a few simple sketches made on the blackboard in the presence of the children.

Plate XXV

Geography

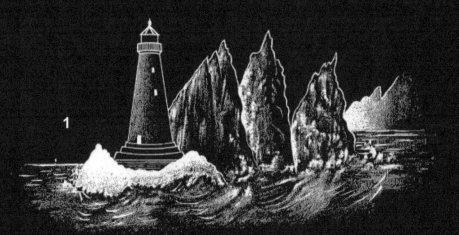

Light-house

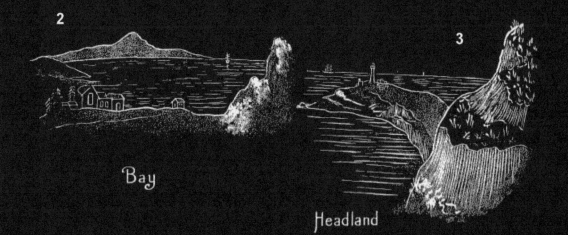

Bay

Headland

ILLUSTRATIONS FOR

HISTORY LESSONS

PLATE XXVI

HISTORY, again, is another subject which most teachers seem to think requires no illustration, since the blackboards are at the end of the lesson generally as guiltless of chalk marks as they were at the commencement. Or perhaps, if the teacher happens to remember that a good lesson should contain blackboard illustration, she carefully writes or prints in large letters the word " History," and the date, at the top of the board, and conveniently forgets to draw or write anything beside this during the half hour or so allotted to this subject.

Certainly it is not quite so easy to make satisfactory historical pictures, but a few minutes some time before the lesson will be quite enough time to enable the teacher to draw a sketch that will amply satisfy her purpose. A series of lessons on London (or the town in which the children live) will give plenty of opportunities for illustrations. Outlines of the famous buildings, as that shown on Plate XXVI, which need not contain much detail in order to be effective, monuments, modes of dressing in the olden times, various conveyances, as the sedan chair, and recent inventions of many kinds, which will show the progress of civilisation—all these are easily adapted to blackboard drawing. Again, notable bridges, old ruins around which various stories and legends gather,

Plate XXVI

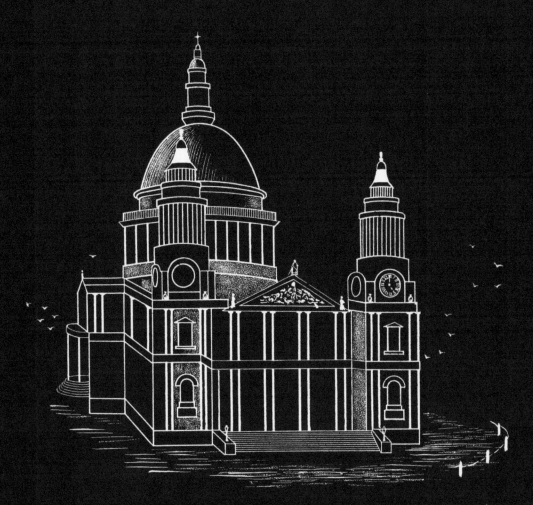

St. Pauls Cathedral is built on the highest ground within
the City of London, in the form of a cross.
The workmen took 35 years to finish building this large Church

castles, and towers, besides various implements used in agriculture, commerce, and warfare—all these will furnish plenty of material wherewith to embellish and make interesting the often dry accounts of historical periods. At the end of each lesson it is advisable to let children compose some sentence about it. This should be written on the blackboard, and copied from thence into their own books. Under the illustration of St. Paul's Cathedral is a sentence suitable to be written by the children.

These three subjects—Number, History, and Geography—have been chosen, not because they are the only subjects which admit of illustration, but because they are so frequently dry and uninteresting when lacking pictures and photographs.

Stories, games, building and object lessons, are so often made the subject of blackboard drawing in good Kindergartens that it is needless to speak of them here. With plenty of practice, and use of the observing power, the student will soon find herself capable of illustrating any subject that may be spoken of in the course of her chats with the little ones.

Plate XXVII

Facsimile of Photographs taken from
the Blackboard after Children's lesson.

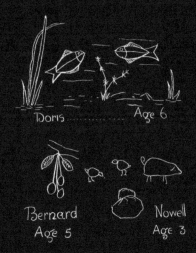

Doris Age 6

Bernard
Age 5

Nowell
Age 3

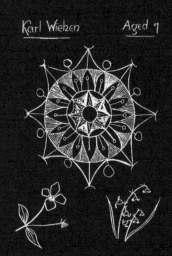

Karl Wiehen Aged 9

Action Song illustrated by a
Student

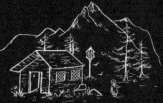

Up yonder on the mountain
There stands a house so high
And from it every morning
Two turtle doves do fly

Printed in the USA
CPSIA information can be obtained
at www.ICGtesting.com
CBHW060751070724
10941CB00010B/133